THE
Zen Art Book

THE
Zen Art Book

The Art of Enlightenment

Stephen Addiss

John Daido Loori

SHAMBHALA
Boston & London
2009

Shambhala Publications, Inc.
Horticultural Hall
300 Massachusetts Avenue
Boston, Massachusetts 02115
www.shambhala.com

© 2007 by Stephen Addiss and John Daido Loori

The Zen Art Book is adapted from *The Zen Art Box*
(Shambhala Publications, 2007).

9 8 7 6 5 4 3 2 1

FIRST EDITION
Printed in China

♾ This edition is printed on acid-free paper that meets the
American National Standards Institute z39.48 Standard.
♻ Shambhala Publications makes every effort to print on recycled
paper. For more information please visit www.shambhala.com.

Distributed in the United States by Random House, Inc.,
and in Canada by Random House of Canada Ltd

Library of Congress Cataloging-in-Publication Data
Addiss, Stephen, 1935–
The Zen art book: the art of enlightenment /
Stephen Addiss, John Daido Loori.—1st ed.
p. cm.
ISBN 978-1-59030-747-2 (pbk: alk. paper)
1. Painting, Zen. I. Loori, John Daido. II. Title.
ND197.A33 2009
755'.943927—dc22
2009010431

Contents

Art as Teacher

John Daido Loori

It was evening in late fall of 1991. At Zen Mountain Monastery, a small group of resident students was gathered around an old Zen master visiting from Japan. Gyokusei Jikihara Roshi, abbot of Kokusei-ji Zen temple, was on the verge of creating a large *nanga* painting, a form of painting that developed in China and that includes both monochrome and color brushwork. *Nanga* painting differs from *zenga* in that in the latter, paintings tend to consist of simple, direct, bold brushstrokes that are often executed in a single breath. Nanga, on the other hand, is more representational. It also evolves over a longer period of time, with each brushstroke suggesting the next.

During its early history, Zen was influenced by the refined practices of Chinese poetry, painting, and calligraphy. *The Tao of Painting,* a book written around 500 C.E., is the canon on the art of painting as a spiritual path. Taoist teachers often communicated their spiritual understanding with painting and verse, and the Zen monks who followed Bodhidharma, the First Ancestor of Zen, took up this tradition. The Taoist approach to art was unique: it was centered on an intimate connection between teacher and student and involved learning to express the energy, or *qi* (J.: *ki*), of the subject. Zen borrowed from these teachings to develop particular styles of painting, calligraphy, and poetry.

By the Song dynasty in China (960–1279 C.E.), the Zen arts reached a high stage of development with a novel phenomenon: the emergence

of painter-priests and poet-priests who produced art that broke with all standard forms of religious and secular art. This art was not representational or iconographic. It did not inspire faith or facilitate liturgy or contemplation. It did not function to deepen the devotees' experience of religion. It was not used in worship ceremonies or as a part of prayer. Its only purpose was to point to the nature of reality. It suggested a new way of seeing and a new way of being that cut to the core of what it meant to be human and fully alive. To this day, Zen art touches artists and audiences deeply. It expresses the ineffable as it helps to transform the way we see ourselves in the world.

Jikihara Roshi spent some time at Zen Mountain Monastery as teacher-in-residence, and I had numerous opportunities to watch him display his skill. These demonstrations reminded me of the times I had watched one of my early Zen teachers, Sōen Nakagawa, do calligraphy, but the intervening years of training and study had given me a deeper appreciation of the way Jikihara Roshi's art embodied the timeless principles of Zen.

Eighty-year-old Jikihara Roshi was a recognized lineage holder in the Japanese Obaku (Ch.: Huangbo) school of Zen, which, together with the Rinzai and Soto schools, is one of the three Zen schools still active in Japan. Its head temple, Mampuku-ji, is at Uji in Kyoto. The school was named after the Chinese Zen master Huangbo, and its teachings traveled to Japan sometime in the seventeenth century. Huangbo Zen took shape during the Ming dynasty in China from a mixture of Zen and Pure Land Buddhism, and through the years it developed a following.

That evening, we watched intently as Jikihara Roshi prepared his tools for painting. His wrinkled face and mane of white hair conjured the image of a master from ancient China. His hands moved carefully and deliberately as he laid out a large sheet of rice paper and anchored the corners with small pebbles. Next, he laid out several brushes, a shallow dish, a small container of water, an inkstone, and an ink wedge.

He silently began making ink by pouring some water into the inkstone and rubbing the wet stone with a wedge of pressed pine resin containing carbon soot. He worked with an intense attentiveness, constantly examining the ink's density and viscosity.

When he was satisfied with the ink's quality, he began to work one of the brushes into the ink, dipping it, rotating it, pressing it along the inkstone until he had just the right amount of flexibility and ink. He tilted slightly forward over the paper, the brush in his right hand. He seemed suspended in space. Everyone was quiet. The only sound was the crackling of the fire in a large stone fireplace that heated the hall. Watching him, I felt like he was drinking in the blank sheet of paper, imagining the space filling with the image. His brush moved to a precise spot in this empty space. A dab of ink activated it. The dance began.

At first, Jikihara Roshi's movements were slow and deliberate. He painted a pair of eyes, then the head, then the body. As the image unfolded before our eyes, I noticed that the first spot of ink had defined what began to grow out of and around it. That first spot was like the seed of a pine tree. When the pine takes root at the edge of a cliff, its trunk and branches are stunted and the needles short. The same seed planted in a forest grows narrow and tall with branches that have a very short reach. In the middle of an empty field, the trunk is wide and the branches reach out many feet, the pine's shape rounder and taller. The tree's growth and development always responds directly to the environment, to the nutrients, soil, temperature, and weather in which it finds itself. Likewise, the shape that follows the first brushstroke on paper is an organic response to form and its environment. The painting evolves from the dynamic interplay between the painter and the circumstances. If the painter begins with preconceived notions of what the finished work should look like, his or her ideas will preclude the possibility of exciting accidents of the brush like the splattering of ink or the wonder of unfolding discovery that gives so much of Zen painting its character and richness.

To get a range of tones out of one stroke, Jikihara Roshi would soak a brush in water and ink to produce a shade of gray. The tip of the brush was then dipped into pure black ink. As Roshi moved the brush over the paper, he guided it carefully while pressing the heel of the brush so the gray color would spread. As the painting unfolded, Roshi's brushwork became swifter. It was astonishing to watch a man his age move with such energy and vitality. It was as if he was drawing *qi* from the art as it evolved, and then returning it to the painting in subsequent brushstrokes.

His last marks were slight yet very precise touches of the brush. I noticed that at that point the smallest stroke had the power to drastically alter the piece's appearance and mood. Finally Jikihara Roshi stepped back from the painting and took it in. He then wrote a short verse on its edge and put the brush down on the table. We applauded. He bowed.

The painting was a classic presentation of the seventh century Chinese poets Hanshan (J.: Kanzan) and Shide (J.: Jitoku), two recluses who lived during the Tang dynasty on Cold Mountain in China. In Jikihara's presentation, the two mountain hermits were reading a sheet of poetry and laughing together. They were known for their profound realization and their simple lifestyle. Throughout history, they've been a favorite subject for painters, and countless scrolls depict them. Jikihara's was one more of these paintings, yet his brushwork gave the subject a unique and completely new expression, full of mirth, lightness, and a deep feeling for life (fig. 1).

The term *zenga* translates literally as "Zen painting," and it describes one of three things: (1) a painting done by a Zen master; (2) a painting by a Zen artist that embodies a Zen theme; or (3) a painting of a particular style that includes bold brushstrokes, simplicity, directness, and humor. In terms of its relationship to Zen, perhaps the most important characteristic of *zenga* is its intent—that is, its ability to visually communicate the teachings of the buddhadharma.

Historically, Zen paintings have been used as "visual discourses," and like the koan in Zen, they are said to be "dark to the mind but radiant to the heart." That is, they cannot be grasped through linear, sequential thought. They speak instead to another aspect of human consciousness that is direct and immediate and they necessitate a process of discovery rather than the transmission of information or ideas.

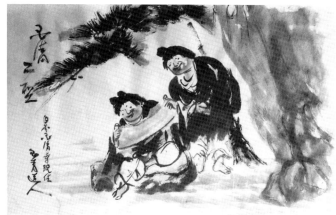

Figure 1.
Hanshan and Shide,
Gyokusei Jikihara Roshi (Mountains and Rivers
Order, National Buddhist Archive).

Sōen Nakagawa Roshi, a Rinzai master and abbot of Ryūtaku-ji Monastery, was a master of *zenga*. He was an impish man of sixty-five when I met him, a bit over five feet tall and with the shaved head of a monk. He was always dressed in robes. Portraits show him as serious, even severe, but in truth, Sōen Roshi was extremely playful and quite a bit eccentric. One moment, his deep, gravelly voice would boom with great dramatic effect, the next, his craggy face would soften, breaking into the sweetest of smiles.

On one occasion, I watched Sōen Roshi as he created calligraphy. He entered the room in which I was waiting with a couple of students carrying a tray and a roll of *sumi-e* paper. He smiled at us and bowed, then spread out a long sheet of paper, anchored the edges, laid out

his brushes, and began to make ink. The ink slowly thickened until it finally reached a consistency that satisfied him. He wet his brush and sat in silence, poised over the white sheet of paper. Then, with a single smooth gesture, the blank space leapt into dynamic tension with the brush. The second, third, and fourth strokes laid out characters; each stroke complemented the previous one, activating the blank space around it. He then diluted the ink by dipping the brush tip in water and added light gray characters to his work. In the same gray ink he signed his name in Japanese and Roman characters and added his seal. He bowed to the painting, and then to us. The whole process was completed in a few minutes.

The deep stillness that Sōen Roshi had cultivated through years of zazen was evident in all of his activities, whether he was teaching, painting, or writing poetry. His every movement was centered and completely present. When Roshi did calligraphy, I could see his whole being shift. He became very quiet, motionless, and I could feel the same stillness descend on me as I watched. Though what I saw in front of me was just a Chinese character, each time I felt as if the piece of art was all there was to see. It filled the universe. Sōen Roshi disappeared; I disappeared. There was no longer any separation between the art, the artist, and the audience.

Sōen Roshi also embodied an astonishing degree of freedom, an ability that blurred the edge between art and life. While visiting the house of a friend who studied Zen with Roshi, I noticed a watery red calligraphy signed with Sōen's name hanging over the bar in the recreation room. I asked my friend about it and he said that during one of Sōen Roshi's visits, my friend offered the master a drink. Roshi pointed to an attractive bottle of grenadine. The host tried to persuade Roshi to drink something else, explaining that grenadine is not usually imbibed straight, but Roshi persisted. My friend poured him a healthy shot of the red syrup in a brandy glass. As the master lifted the glass to his lips, he realized his mistake, but without mis-

sing a beat, he placed the glass back on the bar and asked my friend for his brush. Then he proceeded to execute a beautiful calligraphy using the syrup instead of ink.

Sōen Roshi's style of teaching Zen was as liberating as his capacity with the brush. He remained true to tradition, yet never allowed his teaching to become stale, predictable, or conventional. You had to be on your toes to study with him, and you couldn't take anything for granted. He was always full of surprises. If someone asked him a question, he might just as easily answer it with a piece of calligraphy, a drawing on a napkin, a short haiku, or a bit of *noh* drama.

As powerful as the visual aspects of *nanga* and *zenga* are, just as important in these kinds of works is the writing associated with them. Most Zen paintings include a short inscription in prose or verse called *san*. *San* are composed either by the artist or a third person invited by the artist in order to deepen or clarify the religious content of the image. Many of the classical *zenga* are Zen koans expressed visually and poetically, and the natural environment has been the traditional subject matter for this kind of expression. It is said that a single *zenga* of nature, combined with *san*, can be the embodiment of our true self.

It is important to keep in mind that Zen paintings embody spiritually and artistically the teachings of Zen masters and in this they differ dramatically from Buddhist art in general. They tend to be free, uninhibited, humorous, and do not adhere to the usual characteristics associated with Buddhist art or with sacred art in general. Perfection, grace, and holiness are eliminated. Zen paintings do not even aspire to such ideals. They are imperfect, they are worldly, and through their ordinariness they go beyond perfection and holiness. They echo the saying, "If you meet the Buddha, kill the Buddha," which is another way of saying, "Don't put another head on top of the one you already have." Zen paintings are not guided by convention, precedent, or rules, but they instead express the artist's creative energy freely and spontaneously.

Bodhidharma said,

Zen is a special transmission outside the scriptures,
with no reliance on words and letters;
a direct pointing to the human mind,
and the realization of enlightenment.

For the last fifteen hundred years, these four points have acted as guideposts for the Zen teachings, which are essentially ineffable. And so from the earliest beginnings of the tradition, Zen masters have used the creative arts to try to express the inexpressible.

Despite the Zen arts' strong connection to the Zen monastic tradition, it would be misleading to say that these disciplines are relevant only for those studying within a monastic setting. Spiritual illumination is known to take many forms, and part of the strength of the Zen arts has been their ability to reach beyond the walls of the monastery into secular life.

Some years ago I was asked to photograph a number of art pieces that would be used to illustrate a book on Zen. One of these pieces was a *sumi-e* brush painting of Jizo Bodhisattva, who is known as the protector of travelers, women, and children. This particular Jizo had been painted by an elderly woman by the name of Ishikawa Sekiren, and it was unusually large for a *sumi-e* (fig. 2). Over ten feet high and about eight feet wide, it hung at Dai Bosatsu Monastery, where I had first met Sōen Roshi. While inspecting the painting, I noticed a small inscription on one of the corners that read, "Two millionth Jizo." Intrigued, I asked one of the monks about it and he told me the story.

Many years before, close friends of Sōen's had asked him to meet with their invalid daughter, who had grown despondent after a crippling disease ended her dream of becoming a ballerina. All the parents' coaxing had not succeeded in lifting the girl's depression, and neither had therapy. Finally, they turned to Sōen. "But I'm just a monk," he

said. They insisted, and he agreed to see her. It was a brief visit, but after Sōen left the parents saw that he had taught their daughter to use a calligraphy brush to paint a simple *zenga* of Jizo Bodhisattva. Before leaving, Sōen asked the girl to do a painting each day, telling her that he would come back in a week to go over her work. He did, and after praising her paintings, he told her to do several a day, and to number each one. Periodically, he visited her and checked her progress. Little

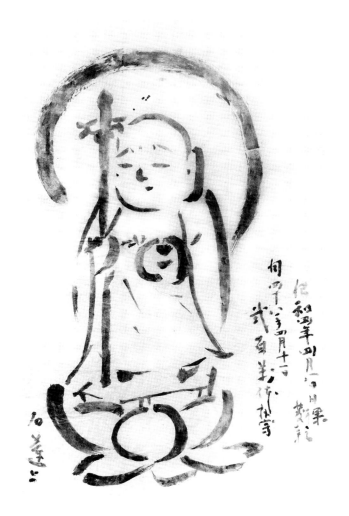

Figure 2. *Jizo,* Ishikawa Sekiren (Mountains and Rivers Order, National Buddhist Archive).

by little, the young girl regained her vitality and the will to live. That girl was Ishikawa Sekiren, who grew up to become a talented *sumi-e* painter.

The two millionth Jizo that I had been asked to photograph was hers, and on that same day I had the pleasure of meeting the artist, then in her eighties. She was still bound to a wheelchair, but her face and eyes showed a radiance seen only in people who have surmounted insurmountable difficulties. It seemed to me that in the process of repeatedly painting Jizo, Ishikawa Sekiren had begun to embody the spirit of the bodhisattva. The painting became a kind of visual mantra that caused in her a palpable transformation.

In general, art has always been transformative. It enlarges the universe, touches the heart, and illuminates the spirit. The Zen arts, because of their emphasis on spiritual insight derived from personal experience, are a powerful tool of self-exploration. They point to a whole new way of seeing ourselves and the universe, and a way of living that is simple, spontaneous, and vital. As the Zen pioneer D. T. Suzuki said, "The arts of Zen are not intended for utilitarian purposes or for purely aesthetic enjoyment, but are meant to train the mind, indeed, to bring it in contact with ultimate reality."

Most important, what is being offered in the powerful and profound teachings of the Zen arts is simply a process of discovery and transformation. If we can appreciate that process and are willing to engage it, we will find before us a way to return to our inherent perfection, the intrinsic wisdom of our lives. And that is no small thing.

Zen Painting and Calligraphy

History and Characteristics

—

STEPHEN ADDISS

INTRODUCTION

Zen painting and calligraphy began very early in Zen history, although no examples are extant from more than a thousand years ago. Earlier written records confirm that Chinese Zen Masters did both painting (such as the Zen circle *ensō*) and calligraphy—sometimes with brush on paper, sometimes with a stick on the ground, and even with gestures in the air. With the introduction of Zen to Japan, Chinese Zen works from the Song and Yuan Dynasties were imported, leading to a tradition of Zen brushwork in Japan that has been carried forth strongly to the present day. During the fifteenth and sixteenth centuries, the popularity of Zen paintings grew so great in Japanese society that major monasteries maintained workshops, certain monks became painting specialists, and Zen art became somewhat professionalized.

After 1600, however, with the decline in the government support for Zen, monastery ateliers were no longer needed, and it became the major Zen masters themselves who created Zen painting and calligraphy, usually as gifts for their followers. There is no parallel for this in Western art; imagine if Pope Julius II, instead of asking Michelangelo to paint the Sistine Chapel ceiling, had painted it himself. The major difference is that Zen masters, having been taught

the use of the brush when learning how to read and write in child-hood, had control of their medium, while Pope Julius was not trained in painting frescos.

As a result of Zen masters creating their own art, the works became generally simpler, more personal, and more powerful than the elegant ink landscapes of earlier Zen-inspired artists. Another result was that major historical trends in Japanese Zen were increasingly echoed in Zen art. For example, there were three basic responses from monks to the loss of support from the government. The first was to continue interactions with the higher levels of Japanese society, often through the tea ceremony. Works by Zen Masters from the Kyoto temple Daitoku-ji, with its strong connections to the imperial court, were especially popular for displaying at tea gatherings, such as the single-column calligraphy by Gyokushū, *The Mosquito Bites the Iron Bull* (fig. 1). Not only its evocative Zen text but also its blunt and powerful brushwork would have been subjects for discussion during the ritual sipping of whisked green tea.

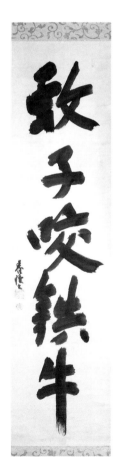

Figure 1.
The Mosquito Bites the Iron Bull,
Gyokushū
(private collection).

12

A second trend in Zen during the seventeenth century was to ignore the governmental restrictions on society and concentrate on one's own practice. This is exemplified by Fūgai Ekun, who left his temple to live in a mountain cave. His portrait of the wandering monk Hotei, who also preferred not to live in temples, shows Fūgai's extraordinary concentration of spirit through its great simplicity of composition and dramatic focus on Hotei himself (fig. 2).

A third trend, however, became the most significant in later Japanese Zen: to reach out as never before to every aspect of Japanese society. Hakuin Ekaku, generally considered the most important Zen master of the last five hundred years, was prodigious in his abilities to

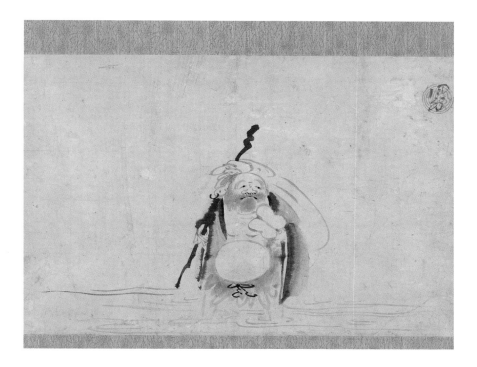

Figure 2.
Hotei Wading a Stream,
Fūgai Ekun (Gubutsu-an).

connect with people of all ranks of life. For example, in addition to guiding many monk pupils, he also taught lay people, giving them his own koan, "What is the sound of one hand?"

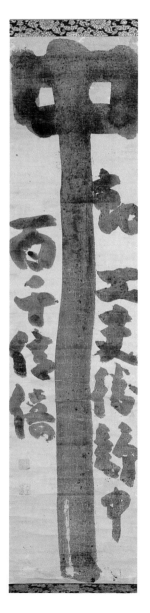

Hakuin also spoke at public Zen meetings throughout Japan, and his voluminous writings include autobiographical narrations, commentaries on Zen texts, letters to everybody from nuns to merchants, poems in Chinese and Japanese, and Zen songs; he also created an amazing array of Zen paintings and calligraphy. In addition to painting familiar Zen themes from the past such as the first patriarch Bodhidharma, Hakuin invented a whole new visual language for Zen. This included scenes of the human condition; folk tales; pictures of birds, insects, and animals; and various humorous subjects of his own invention. In his teachings, as in his calligraphy "Chu," Hakuin emphasized the importance of bringing Zen practice to every aspect of everyday life (fig. 3).

Figure 3.
Chu,
Hakuin Ekaku
(Shin-wa'an).

14

Hakuin's teachings came to have a pervasive influence upon both the Rinzai and Obaku Zen traditions, and his example as an artist was also a great influence on later monks. Zen masters such as Sengai continued to invent new painting subjects, often humorous, while direct and indirect pupils of Hakuin such as Tōrei, Suiō, Reigen, Shunsō, and Sozan followed stylistic trends that Hakuin had developed in his brushwork. Twentieth-century monk artists such as Nantembō continued to be influenced by Hakuin, as can be seen in the work where Nantembō dipped his hand in ink, stamped it on paper, and wrote above it "Hey Listen!" (fig 4).

ZEN BRUSHWORK

The special, simple, and dramatic qualities of Zen paintings and calligraphy from the last four centuries have become increasingly popular lately, but they have not always been as widely admired. For many years, they were appreciated in Japan by followers of Zen, but not necessarily considered as forms of art by others. Instead they were seen as Buddhist teachings, or as the personal expression of Zen masters that somehow stood outside the types of

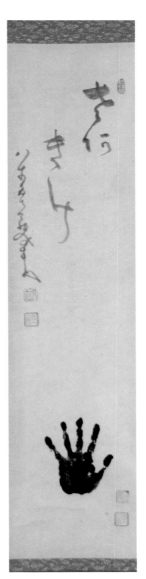

Figure 4.
Hand,
Nakahara Nantembō
(private collection).

works shown in museums. Although this attitude is now beginning to change, later Zen art has not often been included in general publications such as historical surveys of Japanese art. While scholars recognized there to be something special about Zen painting and calligraphy, they were sometimes made uncomfortable by its lack of traditional aesthetic qualities such as overt skill or decorative appeal. Nevertheless, many connoisseurs who study art of all types and periods appreciate Zen works particularly; such works seem to remain fresh when more obviously "beautiful" works have given up all their secrets. This is a mystery: on one hand Zen brushwork seems very simple, on the other hand its visual appeal seems only to increase over time.

The unique quality of Zen brushwork is a result of an encounter between the artist, the subject of the work, and the medium and format. The third of these elements is the simplest: this art is created with brush and ink (rarely color) on paper (occasionally silk), with the addition of red stamped seals. The most common format is the hanging scroll, although some works are done on hand-scrolls that unroll horizontally, or on fans, albums, or screens; a few are brushed with glazes upon ceramics such as teabowls, cups, or plates. The great majority, however, are done with the most basic of materials: brush and ink on paper. This simplicity has the potential for infinite variations, which come from individual touches of the brush that directly communicate personal character and Zen mind through each work. In this sense, each Zen painting and calligraphy is a self-portrait as well as a visual expression of the Dharma.

In their dynamic brushwork, as well as their elimination of anything extraneous, Zen paintings do not try for realism, and have no need for the suspension of disbelief that more naturalistic paintings invoke—Zen works are clearly ink on paper, as well as whatever subject they convey. In addition, the calligraphy often hides rather than displays technical skill, but expresses the spirit of the text through the

individuality of each master very clearly, following the East Asian understanding that the flexible brush expresses and conveys the inner nature of the artist.

This personal expression, which allows us to sense the individual presence of Zen masters from the past in their art, is further enhanced by the subjects of the paintings and the texts of the calligraphy. Thus a painting of Bodhidharma meditating is simultaneously a portrait of the First Patriarch, an expression of meditation as experienced by the monk or nun who created it, and an insight into the individual Zen mind of that artist. A powerful large-scale rendering of this theme by the nun Gyokusen, an overtly pictorial depiction of Bodhidharma with a calligraphic inscription, is both a personal expression of the artist and a Zen teaching (fig. 5).

An interesting comparison comes between pictures of the Zen master's staff by Seisetsu and Tōrei. Visually, the greatest difference is Seisetsu's brushing the image at a diagonal, which always adds a sense of movement to a painting (fig. 6),

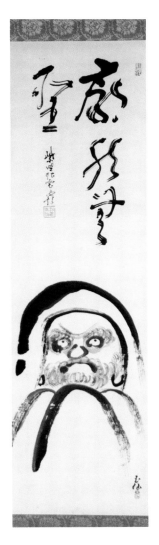

Figure 5.
Bodhidharma,
Gyokusen Kūgai
(private collection).

and Tōrei's creation a strong vertical, which is more stable in form (fig. 7). The result is energy versus permanence, the immediate versus the timeless. Appropriately, Seisetsu's inscription is specific: "Arriving at the place of *mushin* [no mind]—right here!" while Tōrei refers to a classic Zen story about the Tang dynasty master Deshan who said of his pupils, "If they can speak, thirty whacks; if they cannot speak, thirty whacks." In both cases, however, the strong brushwork of both the

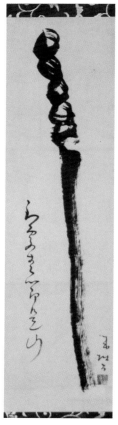

Figure 6.
Monk's Staff,
Seisetsu Shūcho
(Gubutsu-an).

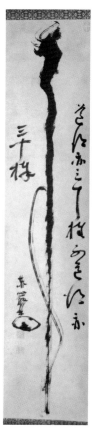

Figure 7.
Staff,
Tōrei Enji
(Shōka Collection).

painting and the inscription gives a sense of each Zen master's vital force.

In both of these painting comparisons, the brushwork and composition help to express more than what words by themselves can convey. Similarly, calligraphy expresses not only the words of which it consists, but also what lies behind them. As in any communication, it is not only what you say, but how you say it, or as a Zen master might teach, Don't tell me—show me.

CALLIGRAPHY

To those of us in the West, who are accustomed to viewing paintings, calligraphy may seem intimidating. Some people assume that if we can't read it, we can't appreciate it. But do we always understand and pay attention to every word of a song that we enjoy? Don't many of us also appreciate listening to opera in a language we don't understand? Meanwhile, we assume that calligraphy is easily legible to people from East Asia, but even great experts have difficulty reading cursive script. And, as though to emphasize that the words themselves aren't necessarily the point, one connoisseur sometimes asks to see a calligraphy upside down at first; he doesn't want to get so carried away with reading the characters that he misses the artistic excitement of line, shape, and form in space. While the meaning of the words is important for total appreciation of calligraphy, words are secondary to the visual element, so those of us who don't read Chinese or Japanese may actually have the best chance of appreciating the art as direct communication beyond words.

There has been some debate among scholars as to how much the meaning of the text influences the style of calligraphy. To explore this question, it may be useful to explore Chinese and Japanese script forms, since each of these has its own potentials for beauty, and then to compare several works included in this book.

It is important to note that Zen masters often wrote in Chinese, and each Chinese character stands for a complete word rather than an element from which words are constructed (as in our Roman alphabet). With its more than fifty-thousand words, Chinese has more than fifty-thousand graphic forms, called characters, giving calligraphy an immense range of visual possibilities, which are further enhanced by the varieties of different scripts available.

The two most ancient scripts in China, seal script and clerical script, were seldom used by Zen masters, except that the seals themselves were almost always carved in seal script, as the name implies. Most Zen calligraphy is written in standard, running, or cursive script, each of which has its own aesthetic. Standard (printed) script, for example, can express balance, firmness, strength, and confidence, but at times it may also convey delicacy and modesty. Running script, which is the most common for everyday use in East Asia, has more sense of movement, since the brushstrokes may be continuous rather than separated. It can express energy, boldness, and naturalness, but sometimes also grace and elegance. Cursive script, the most rapid and also the most difficult to read, conveys spontaneity, impetuosity, and visual drama, but may also be ethereal and refined.

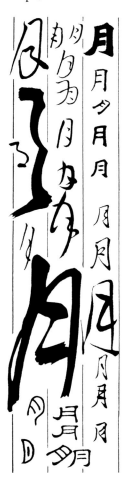

Figure 8.
Varieties of the character for "moon."

20

Each script has its own potential to dance in linear movement through space and time, and each has almost infinite variations. The character for "moon," for example, was originally a picture of a crescent moon, and it has undergone countless variations in the hands of master calligraphers for several thousand years. Figure 8 shows just a few of these in different scripts, with two of the original pictographs on the lower left.

Japanese script, in contrast, uses Chinese characters (usually nouns or basic verb and adjective forms) along with simplified forms that stand for syllables, rather than meanings, called *kana*. This combination of more complex Chinese characters with simplified *kana* gives calligraphy in Japanese its special flavor.

Let's compare some examples of different scripts and styles. The word *mu*, literally meaning "no," "not," "nothingness," was Zhaozhou's answer to his pupil's question "Has a dog the Buddha Nature or not?" As a koan, this *mu* has been meditated upon by monks in training for

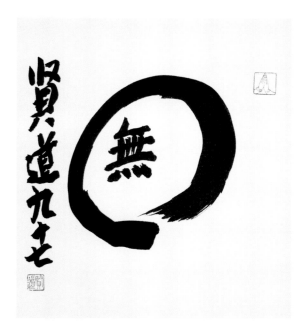

Figure 9.
Mu Ensō,
Kojima Kendō
(Chikusei Collection).

21

many hundreds of years, and it is often brushed by Zen masters as calligraphy. Three examples from the twentieth century are included in *The Zen Art Book*, and each has its own distinctive brushwork. Kojima Kendō, in her ninety-seventh year, wrote *mu* in standard script within an *ensō*. She used twelve strokes of the brush to create the Chinese character, with strong verticals and even more forceful horizontals supported by the four dots at the bottom (fig. 9). In contrast, Nakagawa Sōen created the character on a horizontal format with four strokes, the last of which runs dry of ink. Every stroke conveys movement, including the two dots, and the signature to the left is also full of energy (fig. 10). Fukushima Keidō, the current Zen master and chief abbot of Tōfuku-ji in Kyoto, chose the format to a tall hanging scroll. His single-stroke *mu* in cursive script takes advantage of this vertical format to allow the ending of the stroke to zigzag down toward his signature at the lower part of the scroll (fig. 11). The three masters have used different scripts, formats, and brushwork, yet each conveys the mysterious force of meditating on *mu*.

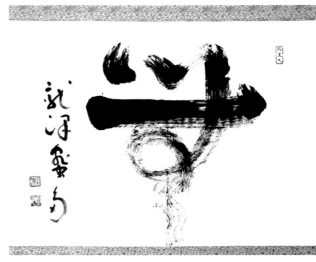

Figure 10.
Mu,
Nakagawa Sōen
(Mountains and Rivers
Order, National Buddhist Archive).

22

A clear example of personal brushwork styles relating to texts can be seen in the "Mumonkan Koan" of Daien Butsu, in which his text about drinking wine is written in a quirky, seemingly intoxicated form of running script that meanders across the horizontal format with a wide variation of line thickness and character weight (fig. 12). In contrast, Inzan's calligraphy of "Complete Understanding" is written in evenly flowing cursive script, beautifully balanced as it serenely flows down the tall hanging scroll format (fig. 13). Another strong cursive work is Deiryū's calligraphy of the single word "Dream," which fades away as it reaches the bottom of the scroll (fig. 14).

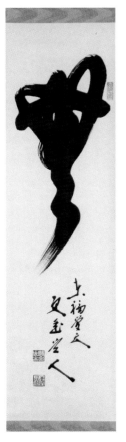

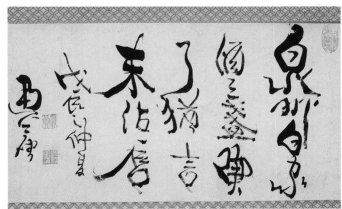

Figure 12.
Mumonkan Koan,
Daien Butsu (Behr Collection).

Figure 11.
Mu,
Fukushima Keidō (Chikusei Collection).

Calligraphic comparisons can also be made between the use of Chinese and Japanese language inscriptions on Zen paintings. Yama-moto Gempō merely wrote the Chinese characters for "longevity" and "radiance" over his painting of a baby, the former in cursive and the latter in standard script (fig. 15). These two words balance evenly above the baby's shoulders in the symmetrical positions that are typical of calligraphy in

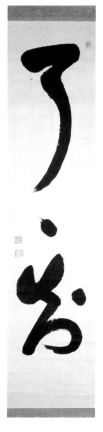

Figure 13.
Complete Understanding,
Inzan Ien
(private collection).

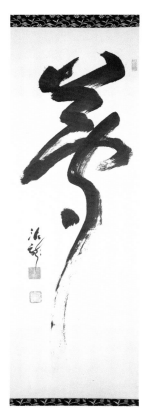

Figure 14.
Dream,
Deiryū Sōjun
(Chikusei Collection).

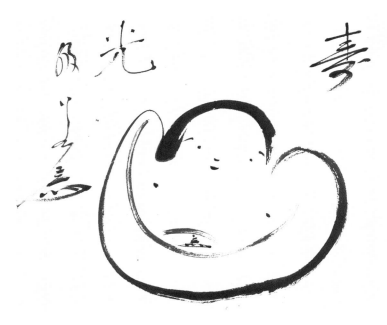

Figure 15.
Baby,
Yamamoto Gempō
(Hōsei-an Collection).

Chinese. Japanese art features much more use of asymmetry, as in Reigen's calligraphy over his depiction of a gun (fig. 16). Here the inscription takes the form of a haiku rendered in three irregular columns that follow the 5-7-5 syllable sections of the poem. Both Chinese and Japanese languages are read downward in columns starting at the top right, but Japanese artists are much more likely to start and end the columns in unexpected places. Instead of the architectural solidity of Chinese characters, the Japanese mix of characters and *kana* syllables conveys a more fluid and transitory sense of life, and fulfills a different standard of beauty.

CONCLUSION

As Zen becomes ever more accepted and understood as a spiritual path in the West, Zen art also becomes better known and appreciated. While the publication of Zen writings—the classics as well as works by modern teachers—has increased exponentially in recent years, exhibitions and catalogues on Zen art have also flourished, especially over the past two decades, allowing Zen art to be appreciated by more Westerners than ever before.

The works presented in *The Zen Art Book* are powerful visual expressions of Dharma by leading monk-artists of the past and present, but

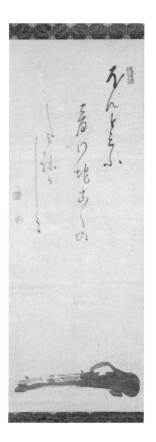

Zen art is not only an historical phenomenon. In Japan, painting and calligraphy continue to be important elements of Zen expression, and masters such as Fukushima Keidō are besieged with requests for brushwork by both monks and laypeople. Concurrently, Zen art in the West is also beginning to flourish, taking some new forms in media such as filmmaking, photography, theater, sculpture, and music. The vital element in these works both new and old, in whatever medium, is the expression of Zen mind. Whether historical or contemporary, the mark of Zen art is the ability to be right here, right now.

Figure 16.
The Gun,
Reigen Etō
(Shōka Collection).

THE
Zen Art Book

Liang Kai (active early thirteenth century)
THE SIXTH ANCESTOR CHOPPING BAMBOO

Art Comment

One of the most famous of all Zen paintings, this work was done by a Chinese court painter who also went into the mountains to discuss Zen with masters living in monasteries overlooking West Lake. Against a rough and simplified background of hills and a tree, the depiction of the Sixth Ancestor engaged in the humble task of cutting bamboo is notable for the short decisive strokes of the brush that depict the figure. While Huineng is doing the chopping, he is also being the chopping.

Zen Commentary

The Sixth Ancestor was an illiterate layman from the south of China who was enlightened upon hearing the *Diamond Sutra* being chanted. He later joined a monastery, where he was first given the job of chopping wood and pounding rice, and later received transmission from the Fifth Ancestor when he was only twenty-four years old. Due to the jealousy of other monks, Huineng was advised to hide himself in the mountains and deepen his spirituality. Fifteen years later he emerged and began teaching. All of the major schools of Zen can trace their history to the Sixth Ancestor. Since the artist was a court painter rather than a Zen master, no inscription was included.

One evening, the Fifth Ancestor entered the rice shack to test Huineng's understanding. He asked, "Is the rice white yet?"

Huineng said, "It's white, but it hasn't been sifted."

The Master struck the mortar three times. Huineng sifted the rice three times and the dharma was transmitted to the next generation.

Ink on paper, 72.7 x 31.8 cm., Tokyo National Museum

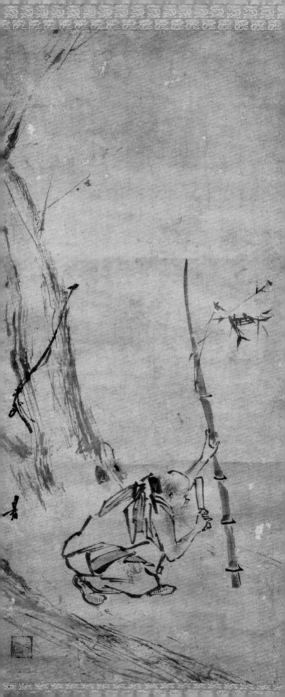

Ikkyū Sōjun (1394–1481)
SILENT SEEING

Art Comment

Ikkyū was not only a leading Zen master but also a great iconoclast. Living during an age when Zen was strongly patronized by the government and wealthy merchants, he decried and mocked the loss of focus in many monks, including some who led major monasteries. His own calligraphy and painting are also individualistic, avoiding overt beauty or skillfulness in favor of direct and honest expression. Here the two characters "silent" (静) and "seeing" (観) have been carved into a wooden board to be hung in a meditation hall or perhaps in a private dwelling. Typically for Ikkyū, the first character on the right is stable and complete while the next word shows more passion and energy. The carver has expertly rendered Ikkyū's idiosyncratic brush-work, including the way a few hairs of the brush sometimes remained on the surface as he moved from stroke to stroke, and also the sense of space that Ikkyū was able to create, not only between, but also within the individual characters.

Zen Commentary

Silent seeing is whole body and mind seeing. Therefore it's not about seeing with the eyes. As master Dongshan said, "If you try to see it with the eyes, you'll never get it. It's only when you see with the ear and hear with the eyes that you will truly understand the Dharma of thusness."

Carved board, 24 x 68 cm., Gubutsu-an

30

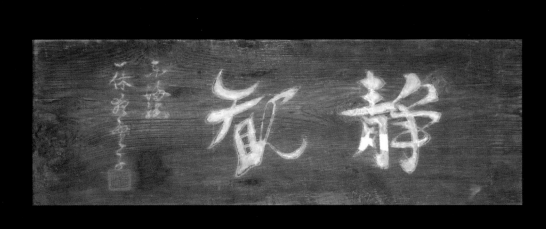

Fūgai Ekun (1568–1654)
HOTEI WADING A STREAM

Art Comment

The monk Hotei (Ch: Budai) is usually portrayed either as a happy-go-lucky wanderer or seated as the "laughing Buddha." Here Fūgai, who himself left temple life to live in the mountains, has shown him simply wading a stream. He does not walk on water like Jesus Christ or fly through the air like Amida Buddha (the Buddha of the Western Paradise), but slings his bag over his shoulder and gets on with his task with a melancholy look on his face. Fūgai omits everything but the monk and the stream, utilizing grey ink and then adding black accents on the robe, the rope belt, the staff, the eyes, the nostrils, and the mouth—these are enough to bring Hotei past cliché and fully to life.

Zen Commentary

Hotei's sack is never empty. It's filled with precious items that range from food to playthings for children, as well as worldly pain and suffering. His mission is to bring peace and joy to those he encounters. Because he is the embodiment of buddha nature, he is usually seen smiling or laughing, but he may also appear to be sad when he identifies with worldly pain and suffering. His benevolence and loving nature have come to signify the results of Zen practice, realization, and actualization.

Ink on paper, 31.2 x 47.3 cm. Gubutsu-an

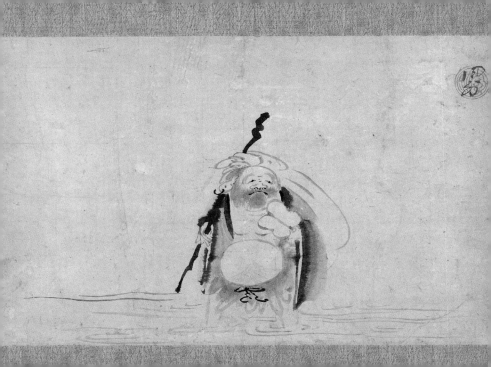

Gyokushū Sōban (1600–1668)
THE MOSQUITO BITES THE IRON BULL

Art Comment

The five characters of this phrase literally represent "mosquito" (蚊子),
"bites" (咬), "iron" (鉄), and "bull" (牛). Gyokushū's brushwork in regular
script only occasionally softens into running script where the strokes merge
rather than remain entirely separate. In only one case do two words touch
each other— appropriately these are "bite" and "iron." The entire work ends
with the final stroke of "bull" deconstructing into "flying white." This verti-
cally extended character creates the impression of a pole holding up the entire
calligraphy, or a tree trunk supporting all the foliage above it.

Zen Commentary

In the Zen tradition, the image of the mosquito attempting to bite an iron bull
is an expression of the impossibility of mastering the Dharmas ("the Dharmas
are boundless," as is recited in the Four Great Vows), and yet of the persever-
ance to pursue this goal ("I vow to master them," as is further recited).

In the traditional ninety-day training period that occurs twice a year in Zen
monasteries, the appointed chief disciple sits in front of the hall facing the com-
munity and holds up a *shippei*—a broken longbow—and says, "This is a three-
foot-long black snake. A long time ago, it had become a konpura flower on Mount
Gridhrakuta, and at Mount Shorin it had become a plum blossom. Sometimes
it transforms into a dragon and swallows the heavens and the earth. Sometimes
it transforms into a diamond sword with the freedom to kill and give life. Right
now, in accord with the order of my teacher, it lies in my hands. I feel like a mos-
quito trying to bite an iron bull. However, being assigned as chief disciple I have
to fulfill my duties. Now, you dragons and elephants in this dharma hall, confront
me in dharma combat!" Like the calligraphy, this statement embodies powerful
simplicity, and it is an expression of both modesty and great determination.

Ink on paper, 139.5 x 39.9 cm., Private Collection

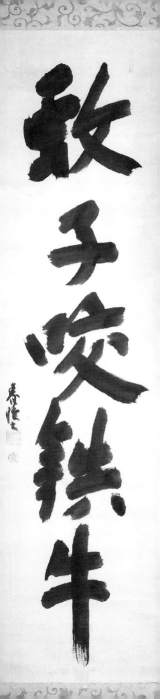

敬子愛鉄牛

Ryōnen Genso (1646–1711)
THE SPIRITUAL BODY

The completely enlightened spiritual body has not one thing.

Art Comment

Ryōnen became famous in Japan because, not content to practice in a woman's monastery, she asked a male master to allow her to study at his temple. When told she was too beautiful and would distract the other monks, she burned her face with an iron, writing:

> Formerly to amuse myself at court I would burn orchid incense,
> Now to enter the Zen life, I burn my own face

As a result, she not only was allowed to practice, but eventually succeeded her teacher to become a celebrated Zen master and abbot in her own right. Her calligraphy here is in the bold and fluent Obaku tradition, with some influence from the monks who had recently immigrated from China, but it also demonstrates her own elegant, eloquent, and decisive style.

Zen Commentary

"The completely enlightened spiritual body has not one thing." It is formless. It is the pure *dharmakaya,* the absolute basis of reality, the source of everything, including buddha activity. The completely enlightened spiritual body is the experience of transcendence of form and the senses, and the realization of true thusness, and yet, it is nothing other than the body and mind of all beings. Because it fills the universe, it contains everything; there is nothing outside of it. Thus, there is not a single thing for the "enlightened spiritual body" to hold on to.

Ink on paper, 109.6 x 24.89 cm., Gubutsu-an

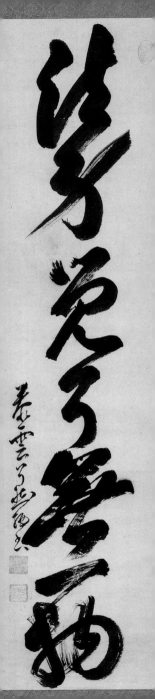

Hakuin Ekaku (1685–1768)
Blind Men Crossing the Bridge

Both inner health and the floating world around us
Are like the blind men's round log bridge—
A mind that can cross over is the best guide.

Art Comment

In his ability to reach out to people in every part of society, Hakuin created a new visual language for Zen, inventing painting subjects from folklore and everyday life. For example, noticing that there was a dangerous log bridge over a gorge near his temple, Hakuin visualized three men trying to cross over, a common metaphor in Buddhism, and to add to the difficulty, he imagined them as blind. The first reaches out with his staff, the second gets down on fingers and toes, and the third puts his sandals on the end of his staff for balance like a tightrope walker. The figures are tiny, created with only a few simple strokes, but within the empty space that Hakuin allows above and below them, they can focus our attention on the physical and spiritual journey.

Zen Commentary

The great master Hakuin is pointing to the difficulties we encounter while attempting to navigate our lives. He advises that a mind that can cross over is the best guide. I ask you, what is the mind that can cross over? What does it mean not just to look, but to see? "Seeing" is a whole body and mind activity in which the separation between seer and seen has completely dissolved. As Thoreau said, it is a seeing that "is beyond the verge of sight." At just such a time the "mind that can cross over" realizes that the other side and this side are a single reality.

Ink on paper, 19.2 x 67 cm., Shōka Collection

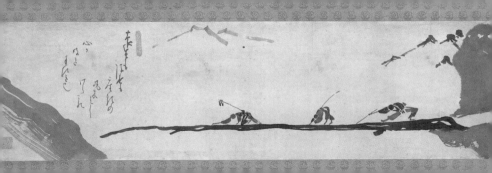

Hakuin Ekaku (1685–1768)

CHU ("WITHIN")

Concentration within activity
Excels that within stillness
A hundred thousand million times.

Art Comment

In his insistence that meditation be carried into everyday life, Hakuin often brushed a calligraphy dominated by the large character meaning "middle" or "within" (中). The graph itself is made up of a rectangle divided by a line, but Hakuin continues his vertical brushstroke down the entire length of the scroll, forcefully dividing the space for his inscription on either side. The blunt force of the work, with its varied tones of ink, establishes it as one of Hakuin's "old age" works, done in his early eighties, when he created paintings and calligraphy of massive power.

Zen Commentary

The still point of zazen, once established, lives in all of our activities, whether we're sitting or standing, working or eating. It is the backward step of all the buddhas and ancestors since time immemorial. It is not meditation, contemplation, quieting the mind, focusing the mind, mindfulness, or mindlessness. It is simply a way of using your mind, living your life, and doing it with other people. But no one can provide a rulebook to go by. Each one of us must go deeply into the self to find the foundations of zazen.

Ink on paper 120 x 28.4 cm., Shin-wa'an

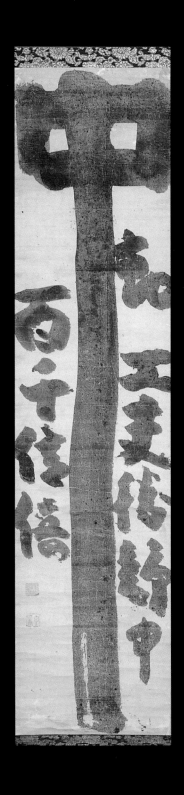

Hakuin Ekaku (1685–1768)

CURING HEMORRHOIDS

It seems he has hemorrhoids—
So I give him one touch of fire.

Art Comment

This unique and surprising painting is one of Hakuin's rare works in color, and we can see some of his preliminary outlines before he completed the work. A homely geisha with "long life" inscribed on her robe applies *moxa* to an old man with the word "money" on his jacket. *Moxa* is a powdered medicine, pressed into cones and burned on the skin to draw out noxious elements. It is usually applied on the back, but here it reaches toward his nether parts while he screws up his eyes and faces the final word of the calligraphy, "fire" (火).

Zen Commentary

Contrary to legend, sitting long periods of zazen does not create hemorrhoids. In spite of the belief that *moxa* works, fire will not cure hemorrhoids, though it will surely create a sense of hell. Hakuin's imagery notwithstanding, there is ultimately no relationship between the "money" on the jacket of the old man and the "long life" on the jacket of the geisha. Aside from this, there is no other truth to be seen.

Ink and colors on paper, 55.7 x 64 cm., Eisei Bunko Foundation

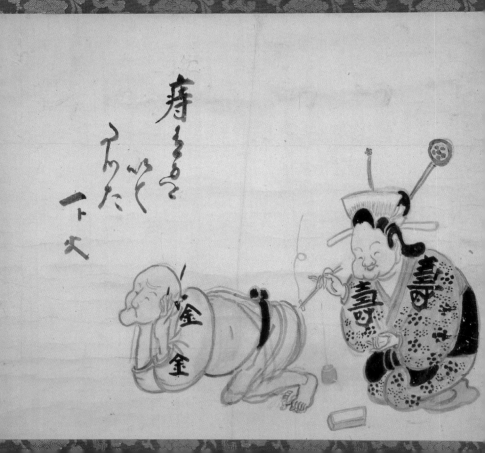

Hakuin Ekaku (1685–1768)
HOTEI PLAYING KICKBALL

Hotei has a happy face—he's playing kickball!

Art Comment
Another of Hakuin's rare works with color, this painting depicts the happy-go-lucky monk Hotei enjoying the spring weather under a willow tree by playing *kemari* (kickball). His robe, inscribed with the character for long life, is slipping off his shoulders as he gives his complete attention to the game. The ball goes up, his head and eyes go up, the willow branch and the calligraphy go down—who could wish for a better game?

Zen Commentary
Whether playing kickball, doing zazen, or working hard, when the mind is at peace, the body and the ten thousand things are equally at peace. Equanimity is not something that happens to you, it's about how you practice and live your life.

Ink and colors on paper, 102 x 25.5 cm., Shin-wa'an

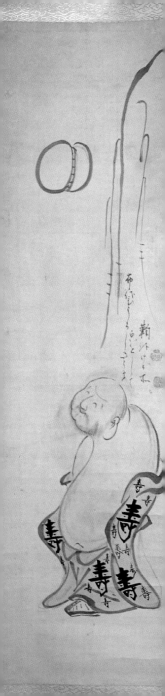

Ryōsai Genmyō (1706–1786)
Hateful Words (1783)

When you encounter hateful words, if you understand,
even these can be a good teaching.

Art Comment

While not as common as single-column calligraphy, two-column scrolls
were also created by Zen masters. Ryōsai was a pupil of Hakuin, but his
calligraphy is quite different in style, emphasizing a combination of fluency
and brisk gracefulness that makes it unique. For example, the second charac-
ter, "evil" or "hateful" (悪), contrasts its jaunty angle on the paper and strong
thin diagonal penultimate stroke with the thicker joined dots at the lower
right, each of which points in a different direction. By leaving sufficient empty
space around the words, Ryōsai allows every character to stand out as a deci-
sive form on its own, while contributing to the total rhythm of the calligraphy.

Zen Commentary

We should ask: What is the understanding that Ryōsai is speaking of? If we
can appreciate the four virtues of a bodhisattva—giving, loving speech, service
for the welfare of all beings, and identity with others—we equip ourselves
with instruments of transformation. Loving speech is a powerful response
to an encounter with hateful words. We should reflect on this and realize
that "The loving speech of remonstrance has the power to influence even the
imperial mind," as Master Dōgen says. This kind of bodhisattva activity is
undefiled by the dualism of self and other.

Ink on paper, 113 x 30.6 cm., Gubutsu-an

觀雲言莫功浴峽
剝筆玉善　　識

Suiō Genro (1717–1789)
Ax

This ax of mine
does away with
people's incompleteness.

Art Comment

Suiō, one of the leading followers of Hakuin, was known for the charm of his paintings, but here he has depicted a jagged-edged ax that fills much of the composition with its sturdy form. Above the ax comes the haiku inscription, visually suggesting another ax-head in three flowing and descending columns, but the center of the scroll is left empty. Is it incomplete?

Zen Commentary

The challenge of master Suiō is in his poem: "This ax of mine does away with people's incompleteness." What is it that stands in the way of one's own completeness? The truth of our lives is that we are born complete and we will die complete, whether we realize it or not. However, to realize it makes the journey from life to death one of ease and freedom, instead of one of pain and suffering. The reason there is pain and suffering is because we have adorned our completeness with the ten thousand illusions that we create and cling to. Suiō's ax cuts away the extra until only the completeness remains. The cutting edge of that ax is the study of the self. The completeness is the forgetting of the self. The ease and freedom is the realization of the ten thousand things as one's own body and mind.

Ink on paper, 119 x 28.8 cm., Shōka collection

Tōrei Enji (1721–1792)
Ensō (Zen Circle)

Above the earth and below the heavens,
I alone am the honored one.

Art Comment

One of Hakuin's major followers and successors, Tōrei, demonstrates in his paintings and calligraphy a powerful and untrammeled spirit that appears most clearly in his *ensō*. There are many of these still extant, and each one is different in size, shape, ink tonality, width of line, and wetness or dryness of brushwork. They are usually accompanied by Tōrei's inscription of the Buddha's first words, as here, where the *ensō* is broad, gray, dry, and fills most of the format with its suggestion of speed and energy.

Zen Commentary

When the Buddha was born he walked seven steps, pointed to heaven with one hand, and to the earth with the other. Then, looking around in the four directions he said, "Above the earth and below the heavens, I alone am the honored one." Master Yunmen said, "If I had seen him at that time I would have killed him with one blow of my stick and would have fed him to the dogs. After all, the world must be at peace." Master Xuedou said, "If I had been there, I would have kicked over his dharma seat." We should understand what these two great masters are pointing to and beware of placing another head on top of the one we already have.

Ink on paper, 33 x 45 cm., Chikusei Collection

Tōrei Enji (1721–1792)
NYOI

What is this?

Art Comment

Tōrei's bold brushwork fills this scroll with the form of a *nyoi* (Ch: *rui*), a short scepter carried by Zen masters. It is usually carved from jade, bone, wood, or bamboo, and has the form of a mushroom of immortality at the top—here depicted with three circular brushstrokes over the thick wriggling vertical. Tōrei added his inscription on the right, and his signature with its mysterious clamshell-shaped cipher on the lower left. But the question remains: What is this?

Zen Commentary

The *nyoi* is used in various ways by Zen teachers to challenge their students. Master Tōrei asks, "What is this?" I would add to the complications by saying, if you have a *nyoi,* I'll give you one, if you don't have a *nyoi,* I will take it away. If you call it a *nyoi,* you're ten thousand miles from the truth. If you say it's not a *nyoi,* you miss it completely. What will you call it?

Ink on paper, 93.7 x 23.8 cm., Chikusei Collection

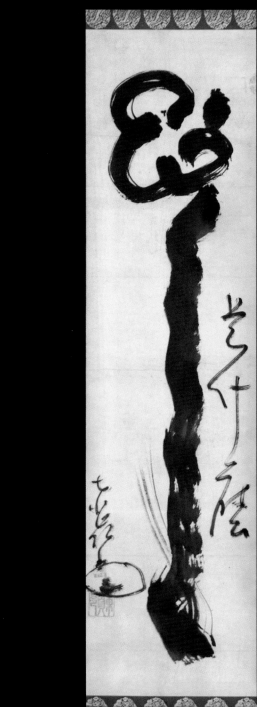

Tōrei Enji (1721–1792)

STAFF

If he can speak, thirty whacks.
If he cannot speak, thirty whacks.

Art Comment
The Zen master's staff carries many meanings and purposes, assisting him on
long walks, transforming into a dragon, or whacking a follower. Here
Tōrei begins the staff with a small swirl of the brush, then moves it quickly
down the length of the format, gradually running dry of ink in "flying white."
After writing his inscription on the right and top left sides, Tōrei added his
signature and clam-cipher in the lower right. The hairs of his brush had split
by the time he began the signature, but undeterred, Tōrei continued in what
appear as shadowed characters, "Tōrei's writing."

Zen Commentary
Master Deshan was fond of saying, "If you can say a word you'll receive
thirty blows of my stick. If you cannot say a word, you will receive thirty
blows of my stick." The word that Deshan is referring to is a turning word,
a word of Zen, a word that can leap free of dualistic thinking and reveal the
nondual dharma. With lips and mouth sealed shut, how would you respond
to Deshan?

Ink on paper, 104.6 x 23.4 cm., Shōka Collection

54

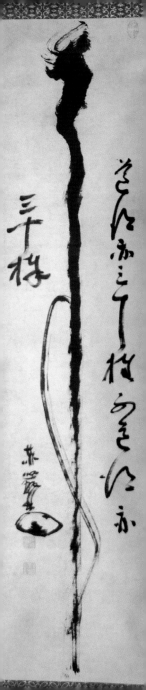

Reigen Etō (1721–1785)
The Gun

The sound of the gun
is the entrance
to hell.

Art Comment

The haiku inscribed on this painting by Reigen literally ends "the island entrance to hell," referring to Tanegashima Island through which guns were imported from Europe. This may seem a strange subject for *zenga,* but Hakuin and his followers were able to use any and every kind of image for their teachings. Here, to emphasize the distance between the weapon and the poem, Reigen paints the gun at the very bottom of the scroll, hemmed in and rigid, although the "flying white" of the rapid brushwork for the barrel gives a sense of the potential movement of its bullets. Reigen is known for his use of gray ink, and above the images, the haiku is written in columns flowing down from the top right of the scroll and fading gracefully away.

Zen Commentary

Indeed, "the entrance to hell." Here we stand over two and a half centuries later and the only difference is that our instruments of destruction have become more sophisticated and efficient, while our way of perceiving the universe and ourselves has remained virtually static. We function with a dualistic view that is based upon the notion of the separation between self and other. As a result, our philosophy, art, science, and morality are based upon this dualistic model with all of its consequences—instruments of destruction. There exists, however, another paradigm for understanding the nature of reality. It requires studying the self and ultimately forgetting the self. To forget the self is to see that self nature and other nature are the same reality. When this is realized, we realize that instruments of destruction are the gateway to not only a personal hell, but the hell of this great earth itself.

Ink on paper, 70.1 x 25.2 cm., Shōka Collection

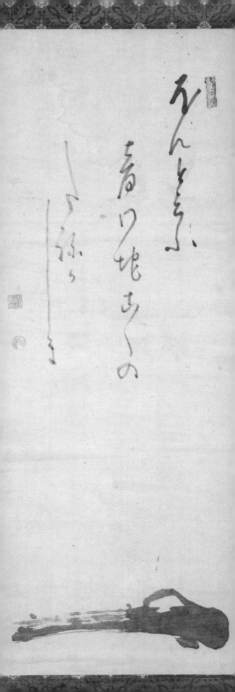

Seisetsu Shūcho (1746–1820)
MONK'S STAFF

Arriving at the place of mushin—right here!

Art Comment

The staff is a frequent subject in Zen painting, here powerfully rendered on a slight diagonal by the early nineteenth-century master Seisetsu Shūcho. After a series of circular forms for the top of the staff, he moved his brush rapidly and strongly downward, creating "flying white" where the hairs of the brush ran dry on one side. The compositional diagonal leaves a perfect space for the inscription, brushed in fluent cursive script requiring only five total strokes of the brush. *Mushin* refers to "no mind," and the final two words literally read "this mountain" (是山), but since every temple is considered to exist on a mountain, Seisetsu is referring to the place where Zen students are studying, which is always right here.

Zen Commentary

If you call it a staff, you're caught up in the words and ideas that describe it. If you say it's not a staff, you negate its existence. Without resorting to speech or silence, tell me, quickly, what is it? This is about arriving at the place of no-mind. No-mind is always this very moment, this very reality. Let go of all ideas, and tell me, what is it?

Ink on paper, 93.6 x 25.9 cm., Gubutsu-an

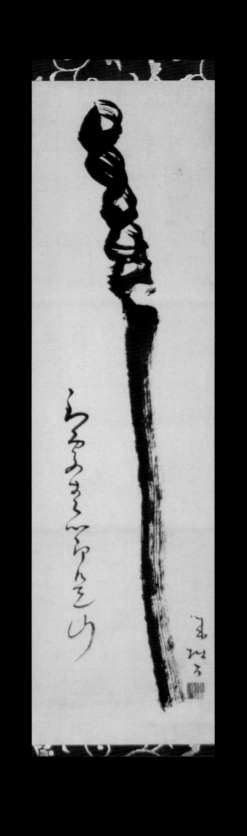

Gōchō Kankai (1749-1835)

TRULY KNOW ONE'S OWN HEART/MIND (1819)

Art Comment

Here, in cursive script, Gōchō creates a unique composition in which the first two characters remain orderly in the opening column, whereas each of the following three words is simplified differently and flows dramatically through space. "Know" (知) broadens out into a horizontal Z form, "self" (身) curls in on itself more vertically with two central dashes joining together like the shape of a butterfly, and the final "heart/mind" (心) leans down diagonally toward the other characters. The feeling of spontaneity is enhanced by the seventy-one-year-old Gōchō's use of gray ink, which is usually blurry-wet and yet shows "flying white" due to the rapid movement of the brush.

Zen Commentary

To truly know one's own heart/mind is to see into the nature of the universe. This very body and mind is the body and mind of the universe. Everything that we encounter arises from the mind. But what is the mind? The great master Bodhidharma said, "You ask, that's your mind. I answer, that's my mind. If I had no mind, how could I answer? If you had no mind, how could you ask? That which asks is your mind." This very mind is buddha, the reality of your own self-nature.

Ink on paper, 28.8 x 57 cm., Shōka Collection

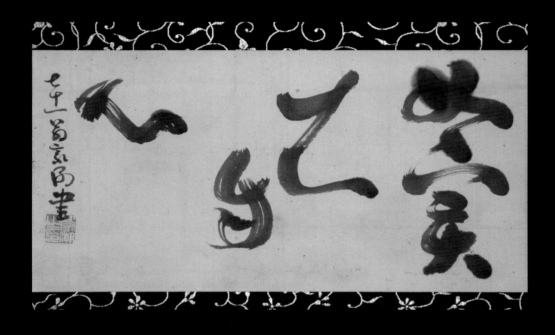

Shunsō Shōjō (1750–1835)
DEMON MEDITATING

Art Comment

The Japanese *oni* is a demon or devil, but although his horned and ugly face can be frightening, he also has a touch of humor as depicted in Japanese art. Here the Zen master Shunsō finds a new activity for the demon: Zen meditation. With his incense stick marking the time of his zazen, the *oni* sits with his legs crossed and hands folded at his stomach. From the expression on his face—mouth frowning, eyes glancing away—we know he is not yet completely reconciled to his spiritual work. We may smile, but isn't he trying to do his best?

Zen Commentary

Even demons can benefit from the backward step of zazen, delusions notwithstanding. You should understand that even in the cave of demons on the black mountain, the one bright pearl's radiance is not diminished. Buried beneath countless layers of delusion, the truth of the universe is present. It's just that it needs to be discovered. The gateway to that discovery is zazen.

Ink on paper, 33 x 46.7 cm., Gubutsu-an

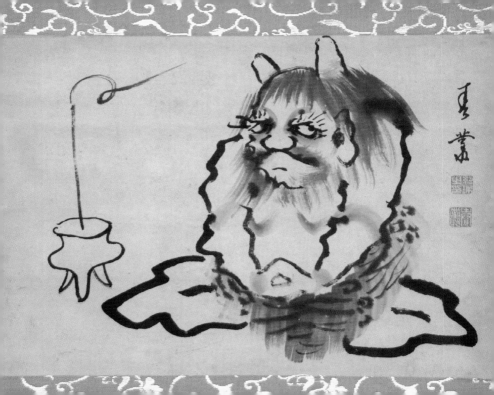

Sengai Gibon (1750–1837)
BASO AND RINZAI (MAZU AND LINCHI)

One *katsu,* three days. The fist strikes the ancestor.

Art Comment

In this pair of scrolls Sengai depicts two of the most famous Chinese Zen masters, adding a touch of humor to keep us from finding them too frightening. Linchi's clenched fist is belied by the dismayed look in his eyes, while the broken lines of Mazu's head, ear, and shoulder seem to soften his fearsome shout, *katsu.*

Zen Commentary

Mazu said to Baizhang, "In the future, if you travel to other places, how do you intend to help the people?" Baizhang picked up a flywhisk and held it upright. Mazu said, "If you use it in that way, what other way can it be used?" Baizhang placed the whisk back on its stand. Mazu suddenly let out an earth-shaking shout (*katsu*) that left Baizhang deaf for three days.

You tell me: was his shout approval, disapproval, both approval and disapproval, neither, or was it an entirely different matter?
 In the case of master Linji, his master, Huangbo, questioned him on his visit to the hermit Daiyu:

> Huangbo said, "What did Daiyu say?" Linji recounted his meeting with Daiyu. Huangbo said, "That old fellow Daiyu talks too much. Next time I see him I'll give him a painful swat." Linji said, "Why wait until later? Here's a swat right now." Linji then hit Master Huangbo. Huangbo yelled, "This crazy fellow has come here and grabbed the tiger's whiskers! Take him to the practice hall."

If you wish to understand the teachings of either of these masters, you must see them from the perspective of their time, place, and position. How do you see from the perspective of their time place and position? Forget the self and *be* the koan.

Ink on paper, each 117.7 x 41.2 cm., Idemitsu Museum, Tokyo

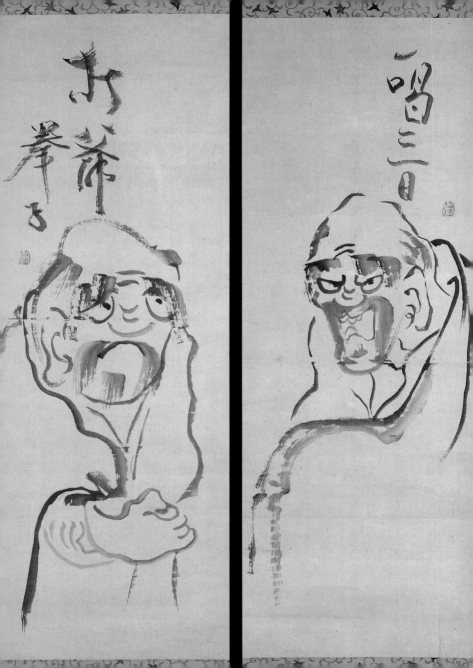

Sengai Gibon (1750–1837)
CIRCLE, TRIANGLE, AND SQUARE

Art Comment

Perhaps no Zen painting has given rise to so many different interpretations as Sengai's rendering of these simple geometric forms. But with more looking and less thinking, we can see that the three basic shapes touch, intertwine, and show varied tones of ink, bringing the forms into lively relationship with each other. Instead of an inscription, Sengai simply adds an elaborated signature on the left, leaving it up to each viewer to interpret, or merely contemplate, the painting.

Zen Commentary

Zen Master Sengai was an accomplished Rinzai master with a deep understanding of the teachings of Zen. This work, although it is usually referred to as, "Circle, Triangle, and Square," was not given a title by Sengai nor did he include a *san* or inscription indicating the teaching. Aside from his signature, all we have is the image he created. What is its meaning? *The visual expression itself!* Historians and commentators have discussed the work endlessly, yet all we have from the master is his silence and the visual expression itself.

Ink on paper, 29.2 x 48.1 cm., Idemitsu Museum, Tokyo

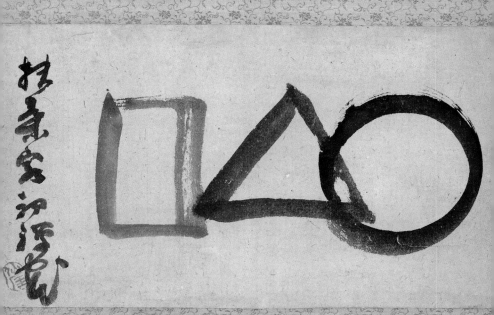

Sengai Gibon (1750–1837)
Frog

If a human can become a buddha by meditating . . .

Art Comment

Sengai noticed one day that the way a frog naturally sits is much like zazen. The result was this delightful painting, which unobtrusively utilizes a number of artistic techniques while appearing as simple as a cartoon. First, the brush-strokes show different tonalities of ink from black to grey, often in a single stroke. For example, Sengai began this painting by filling his brush with gray ink, then dipped just the tip in black before beginning the stroke for the head and shoulders of the frog. We can see the first touch of black, then the darker ink continuing on the inside of the curving line until the brush runs out of ink, creating "flying white" as the stroke ends with a circle for the frog's rump. Second, everything is curved; the calligraphy bends down around the frog, in reverse direction to the stroke just mentioned, but echoing the similar semi-circles depicting the frog's right arm. Finally, the darkest ink is saved for the frog's face, emphasizing his smiling eyes and mouth.

Zen Commentary

The unstated question here is: Can a frog become a buddha by single-minded sitting? The truth of the matter is that not only is it impossible for a frog to become a buddha by meditating, it's also impossible for anyone to become a buddha by meditating. Humans, frogs, mountains, rivers, all things sentient and insentient, as well as this great earth itself, cannot become buddha because they are already there.

Ink on paper, 40.6 x 52 cm., Idemitsu Museum, Tokyo

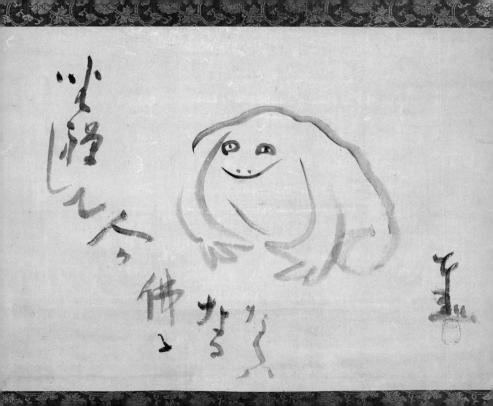

Sengai Gibon (1750–1837)
LION DANCE

Gya-gya [the sound of a baby gurgling].

Art Comment

Like Hakuin, Sengai often chose subjects from daily life for his paintings. He seems to have especially loved children, who often appear in his scrolls, such as this toddler watching a "Lion Dance" with total delight. One charming feature that Sengai added is the upper face of the performer peeping through the break between the costume and the mask. Despite the apparent simplicity of the brushwork, we can see the differences in the depictions of eyes—merely dots for the toddler, more complex for the performer, and round and staring on the mask.

Zen Commentary

"Gya-gya"—these baby sounds of delight are reminiscent of Master Dong-shan's "Jewel Mirror Samadhi," where he says, "Just as in the common infant, the five characteristics are complete, no going, no coming, no arising, no abiding. Ba-ba wa-wa, speaking without speaking." In the *Nirvana Sutra,* the five characteristics of the common infant are equated with the behavior of the Tathagata, the Buddha. An infant is unable to get up, stay put, come, go, or talk. In the same way, the Tathagata does not raise the thought of any dharma, does not abide in any dharma, does not have a body capable of action such as coming or going because he is already in nirvana. In addition, although it is said that the Buddha taught for forty-seven years, in fact, he never uttered a single word.

Ink on paper, 36.2 x 25 cm., Idemitsu Museum, Tokyo

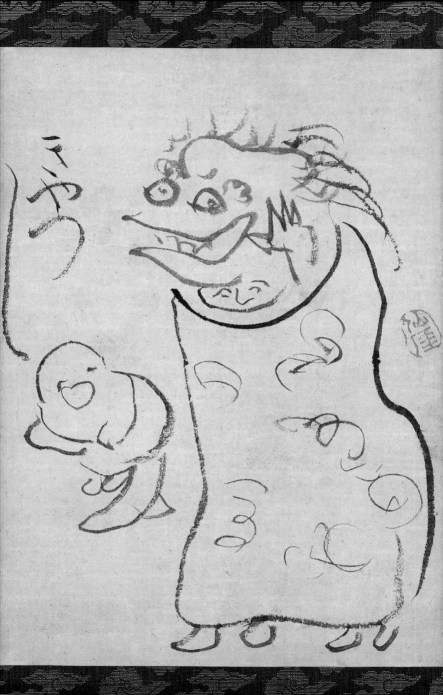

Inzan Ien (1751–1814)
COMPLETE UNDERSTANDING

Art Comment

Inzan has written three characters: ryō (了), ryō (了), and chi (知), with the middle character represented by a dot that acts as a repeat mark. *Ryō* means "complete" and also "finally," while *chi* means "knowing" or "understanding," and so another possible translation of the three characters might be: "finally, finally understanding." The opening *ryō* balances its strong fuzzing horizontal at the top with a long curving stroke downwards, ending with a touch of "flying white." This character occupies almost half the scroll, and also seems to give birth to the single dot below it, a repeat mark, which shows traces of how the brush began it from the upper left. It exactly divides the first from the third character, and yet it also relates to the lower dot to give a sense of continuity. The lower dot, however, has a slightly different and more stable shape, nicely dividing the spaces around it. *Chi* is also a marvel of balance as it swings from upper left up again to the right, moves down with an angular zigzag to the lower left, and finally curves around and back to the right. It is so secure in space that one might imagine a floor below it, but there is nothing but empty paper; Inzan does not complicate matters with a signature but merely adds three seals. Is this work dance or architecture? Certainly both, and much more, which can be left for each viewer to discover.

Zen Commentary

In a universe that's in a constant state of becoming, with nothing permanent, who can say what is complete or incomplete? All we can really know is how to practice that which appears before us. When one dharma appears, one dharma is practiced. In this way, no person ever falls short of his or her own completeness.

Ink on paper, 119 x 30 cm., Private Collection

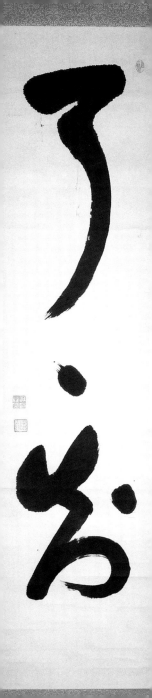

Daien Butsu (d. 1825)
MUMONKAN KOAN

Of Chuanzhou's "White House" wine you have drunk three cups,
But you claim you have not even moistened your lips.

Art Comment

Beginning at the top right, the koan proceeds in four columns, followed by
the date of "1808 mid-summer," and then the signature on the far left. Daien
deliberately exaggerates the strangeness of his calligraphy with odd tilts and
varied sizes for the characters, angular thick/thin lines, and stop-and-go
brushwork rhythms. Two significant words that begin the third and fourth
columns are given more space and weight; these are "already" (了) and "not
yet." (未). Is this calligraphy drunk or sober?

Zen Commentary

In this koan a monastic says to the great master Caoshan, cofounder of the
Caodong school of Zen, that he is poor and destitute, and he begs the master
to help him. At this point we should understand that the monk is claiming a
degree of clarity by making this statement. But Caoshan sees through it and
says, "Venerable monk!" The monk answers, "Yes master!" and Caoshan
remarks, "You've drunk three cups of the finest wine but still you say that
your lips are not yet moistened." The key to appreciating this koan lies in
seeing how the monk drank these three cups of wine.

Ink on paper, 30.4 x 55.9 cm. (1808), Behr Collection

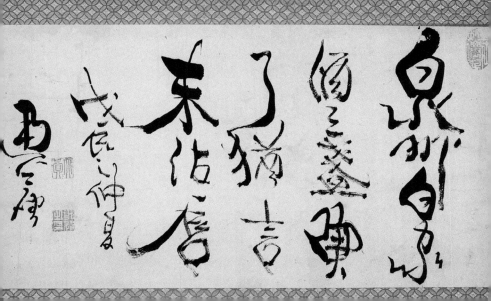

Zōbō Bunga (1779–1840)
The Bridge Flows, the Water Does Not Flow

Art Comment

The five characters literally read "bridge flow water not flow," and Zōbō has utilized bold and flowing cursive script in his brushwork. However, there are three ways in which the meaning of the text is supported. First, the supposedly unmovable "bridge" is rendered in black ink, while the other words are grayer in tonality. Next, the first three characters join one another with continuous brushstrokes, while the final "not" and "flow" each stand separate and alone. Finally, although the final character is the same as the second and resembles it closely in shape, there is more negative space within it and outside it, and it no longer emphasizes the dramatic use of "flying white" where the paper shines through strokes of the brush. In these ways Zōbō has been able to emphasize the meaning of the Zen phrase through strictly artistic means.

Zen Commentary

Zen Master Zōbō Bunga resurrects one of Master Hakuin's miscellaneous koans, "The Bridge Flows, the Water Does Not." This is one of a few hundred koans that follow the koan "Mu" in systematic koan introspection. The question here is, how is it that the bridge flows, and the water does not? Don't explain. Show me. The only entrance into seeing this koan is to abandon your reference system and *be* the koan. Haven't you heard Master Dōgen's teaching, "If one examines the ten thousand dharmas with a deluded body and mind, one will suppose that one's mind and nature are permanent. But if one practices intimately and returns to the true self, it will be clear that the ten thousand dharmas are without self." Just let go of the reference system.

Ink on paper, 101.3 x 28.7 cm., Behr Collection

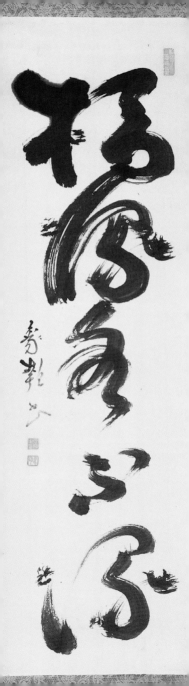

Sozan Genkyō (1779–1868)
FOX-PRIEST

Not caused, not free from cause, a pair of dice of the same color.

An old man would always come to hear Master Baizhang's dharma discourses. One day he confessed to the master that when a student asked him "Does an enlightened person fall into cause and effect?," he said "No, such a person does not." Because of this he became a wild fox for five hundred lifetimes. He then asked, "Please say a turning word for me. Free me of this wild fox body." Baizhang said, "Don't ignore cause and effect."

Freed from his fox body, the old man asked Baizhang to bury the fox body as he would a deceased monastic.

Art Comment

Sozan picks up the koan at the time of the "fox-priest" funeral. His unusually full composition has a central focus on Baizhang, while his followers stand in smaller size behind him. The curving vertical lines that define their robes, and the white space within them, stand out against the grey tones of the rocky enclosure. Holding his staff, the Zen master faces the fox, also primarily composed of white space, in preparation for the cremation. The calligraphy echoes the diagonal from master to fox, with the signature "Sozan" and the seals completing the work.

Zen Commentary

In spite of Master Sozan's calligraphy: "Not caused, not free from cause, a pair of dice of the same color," this koan is not about cause and effect, but rather about duality. If you say: "Falling into causation," you go straight to hell as quick as an arrow. If you say, "Not falling into causation," you are a fox through and through. How will you leap clear of Baizhang's trap? Only Huangbo was able to see through Baizhang's clumsy ghost story. If you fall into the words and ideas or try to imitate Baizhang or Huangbo, you too will be a fox spirit. Say a word that goes beyond dualistic discrimination and free yourself of the fox body.

Ink on paper, 37 x 60.2 cm., Gubutsu-an

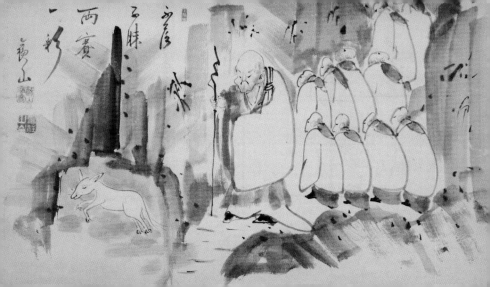

Suigan Bunshū (1810–1874)
THE CAT KOAN

In his right hand he holds the knife
In his left hand, the cat—Speak! Speak!
Quick as a flash, it's already too late.

Art Comment

For this well-known koan, Suigan created almost the entire composition, including the inscription, in gray ink, with black appearing only at the areas of most intense focus. These are the face of the Zen master, the cat itself, and the knife, although there is also a very dark gray at the foot of the figure to anchor the composition. Are we dismayed at the fierce look of the master and the innocent look of the cat?

Zen Commentary

The monks of the West Hall and the East Hall were arguing over a cat.

Master Nanquan held up the cat in his left hand and a knife in his right hand, and said, "Say a word and I'll spare the cat."

No one could speak; Nanquan cut the cat in two.

Later Zhaozhou, who was away, returned, and Nanquan told him the problem and asked him what he would have done.

Zhaozhou took off his sandals, put them on his head, and walked away.

Nanquan said, "Alas! If you had been here I could have spared the cat."

Tell me, what is the magic in Zhaozhou's placing the sandals on his head and walking out? And why did Nanquan feel that Zhaozhou's answer would have allowed him to spare the cat?

Ink on paper, 98 x 30.1 cm., Private Collection

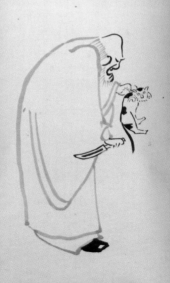

忠持刀子
左提猫兒
道々
石火猶遲

Nakahara Nantembō (1839–1925)
HAND ("HEY LISTEN!") (1923)

Art Comment

For this scroll, instead of painting or writing calligraphy, Nantembō merely dipped his left hand in ink and pressed it down on the paper. Above it he has written in Japanese phonetic script, *Saa, kike!* which means "Hey, Listen!" On the left, he added his age of eighty-five and a signature, stamped one opening and two closing seals, and everything else is empty.

Zen Commentary

Stop! Listen! Nantembō's inked handprint stops us dead in our tracks. The kind of listening he is speaking of involves the totality of our being. It's not just a matter of listening with the ear, or indeed even hearing with the ear. Only when we can "hear with the eye and see with the ear" as Master Dong-shan said, will we be able to enter the realm to which Nantembō is opening the gate.

Ink on paper, 122 x 29.4 cm., Private Collection

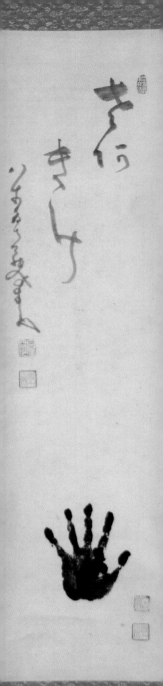

Gyokusen Kōgai (b. 1858)

BODHIDHARMA

Vast emptiness, nothing holy.

Art Comment

The Zen nun Gyokusen was an accomplished painter who enjoyed collaboration; many of her works were inscribed by her male colleagues—in this case by the Daitoku-ji master Sohan Gempō, also known as Shōun. Here, looking directly out at us, is the meditating Bodhidharma, depicted with bold, wet ink tones of gray and black. Since each painting of Zen's First Patriarch is also a portrait of meditation, we can also envision Gyokusen's own understanding of meditation in this powerful and dramatic scroll.

Zen Commentary

When Bodhidharma arrived in China, he was summoned by Emperor Wu, who was both a benefactor and a student of Buddhism.

Emperor Wu questioned the Indian monk: "What is the highest meaning of the holy truth?"

Bodhidharma answered, "Vast emptiness, nothing holy."

Emperor Wu pressed further: "Then who are you standing here before me?"

Bodhidharma said, "I don't know," and with that, he turned and left.

Bodhidharma's first response, "Vast emptiness, nothing holy," and his second response, "I don't know," were completely in accord. If you wish to understand this, you must enter through the gate of intimacy where there is no dichotomy between self and other.

Ink on paper, 139.5 x 39.9 cm., Private Collection

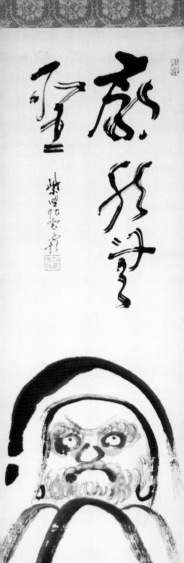

Rozan Ekō (1865–1944)
"Once a Beauty, Now a Skull"

Art Comment

In Japanese culture, viewers would know that this image relates to a famously talented and once beautiful court poetess of the ninth century, Ono no Komachi. After her long life, her skull was supposed to have spoken from the fields to Ariwara Narihira (825–880) with three lines of a five-line *waka* poem, which Narihira then completed:

> Every time
> the winds of autumn blow,
> my eyes are painful, painful . . .
> Don't say it's Ono—
> the pampas grass is growing.

Rozan has contrasted the wet gray brushwork of the tall grasses with dry black brushwork for the skull, which looks out at us with empty eyes.

Zen Commentary

The beauty and the skull are two parts of a single reality. In birth, nothing is added. In death, nothing is lost. The only thing that has changed is form, which is in a constant state of becoming. Can't you hear the words being carried by the wind across the tall grasses? If not, know that you must learn to hear beyond the verge of sound.

Ink on paper, 135.4 x 34.2 cm., Behr Collection

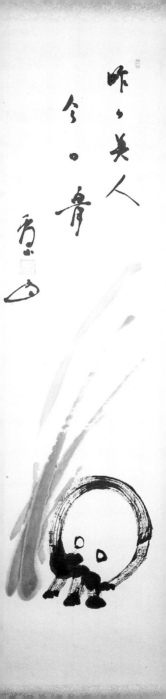

Yamamoto Gempō (1866–1961)
Baby, "Longevity and Radiance"

Art Comment

One of the most beloved of twentieth-century Zen masters, Gempō Roshi taught his followers at Ryūtaku-ji, a countryside temple founded by Hakuin and Tōrei. Rejoicing at the birth of a child to one of his parishioner families, he created this charming image, wishing the child "longevity and radiance" in his two-word inscription. The rounded form and simplified face of the baby make universal the sense of the joy that new life brings.

Zen Commentary

"Longevity and radiance." I would add "infinite potential." A monk asked Zhaozhou, "Does a newborn baby also have the sixth consciousness of mind?" (Eye, ear, nose, tongue, body, and mind.) Zhaozhou answered, "It's like tossing a ball on swift flowing water." The monk also asked Master Touzi, a contemporary of Zhaozhou, "What is the meaning of tossing a ball on swift flowing water?" Touzi said, "Moment to moment, nonstop flow." Each and every moment alive and present, and containing the whole universe.

Ink on paper, 33.5 x 45.3 cm., Hōsei-an Collection

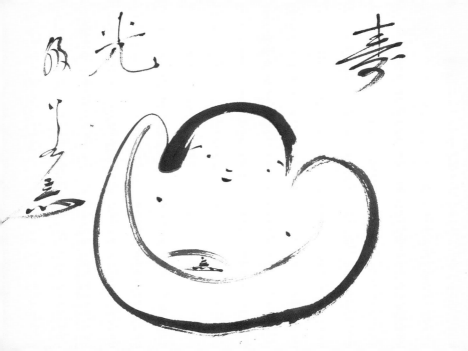

Ten Thousand Dharmas Return to the One

Art Comment

The ability of calligraphy to emphasize certain words is especially apparent in this single-column scroll by Seki Seitsetsu, abbot and Zen master at Tenryū-ji in Kyoto during the second quarter of the twentieth century. The first character, "ten thousand" (萬) is created boldly in cursive script, with "flying white" as the brush rapidly ends the character. The second word, "dharmas" (法) is more modestly expressed, but the third, "return" (帰) is boldly drawn down the length of the format with an extended vertical, showing a strong use of flying white. Beneath it and to the left, the word "one" (一) is short and stubby, and rendered in dark ink. Visually, Seisetsu stresses the activity of returning more than the unity at the end; as best our writing system can show it, he has written "Ten thousand dharmas returnnnnnnn [to the] one."

Zen Commentary

Ten thousand dharmas return to the One. Ultimately, the question is, what is the One? Taking it even further, I would ask you, what does the One return to? If you can clearly see into it here; if you can say a turning word without explanations and without confining yourself to the two mountains of buddha and dharma, then I will grant that you're free to ride the clouds and follow the wind. If you have not yet seen it, then sit single-mindedly with this koan.

Ink on paper, 132.1 x 31.5 cm., Behr Collection

無法而

Deiryū Sōjun (1895–1954)
BEGGING MONKS

One bowl for the rice of a thousand houses

Walking, walking this Buddhist road.

Art Comment

Deiryū's inscriptions make clear that the begging rounds of the monks are part of their training, but his brushwork also adds a touch of humor. At first seeming nothing more than a cartoon, on closer viewing the tonally varied brushwork from black to grey as the monks appear and disappear, the curving movement of the bodies on the tall thin formats, and especially the fact that each simplified face is different from all the others—these show Deiryū's unobtrusive skill and understanding. Walking and chanting, the young monks leave and come back to join us again.

Zen Commentary

These two images show a central aspect of Zen practice and training that is common to all schools of Buddhism. During the begging rounds that monks engage in daily, at the moment that giver and receiver meet, both merge into a moment of unity in which the giver becomes the receiver and the receiver becomes the giver. Rice is placed in the monk's bowl, the monk chants a sutra. This is the actualization of *dana*, generosity, which is the first of the six *paramitas* or perfections in Buddhism. The identity of giver and receiver is essentially no different than the identity of form and emptiness.

Ink on paper, each 121.6 x 16 cm. Hōsei-an Collection

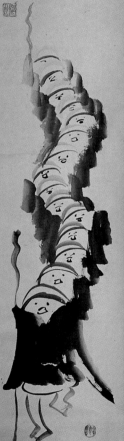

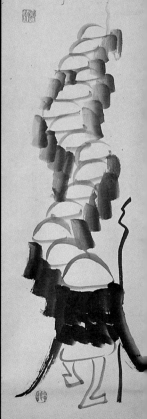

Deiryū Sōjun (1895–1954)
DREAM

Art Comment

In standard script the word dream (夢) is written in thirteen strokes of the brush, but here Deiryū has used only four: the first dot at the top left, the second dot continuing on in a zigzag movement, the curving vertical, and the final dot. To complete the composition, his signature is placed in a space cell on the left. Deiryū has needed no more than a single word to complete his meaning, and the powerful cursive script, ending with "flying white" where the brush runs dry of ink, emphasizes the powerful sense of movement that a dream can embody.

Zen Commentary

The character "dream" plays a pivotal role in Zen because it points to the nature of what we normally regard as reality, and it illustrates the meaning of the Zen phrase "The three worlds are nothing but mind." When he was close to death, the great master Takuan was asked by his disciples to leave a poem. He took up his brush and, like Deiryū, wrote the single character "dream," and then left his body. For him, the ten thousand things and life and death are all a dream. Like the three worlds of form, formlessness, and desire, they are created in the mind.

Ink on paper, 92 x 32.5 cm. Chikusei Collection

94

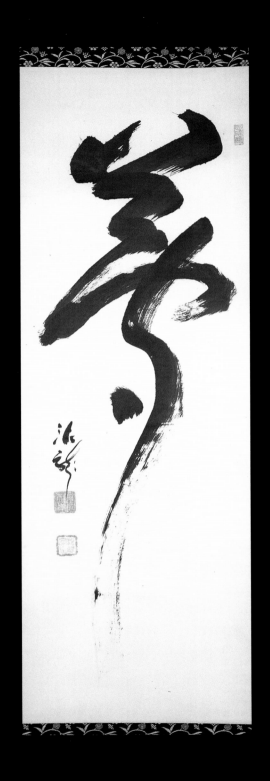

Gyokusei Jikihara (b. 1904–2005)

Ten Ox-Herding Paintings, 6: Riding the Ox and Returning Home (1982)

Win or lose, returning home
Playing a no-hole flute.

Art Comment

The ten ox-herding poems and paintings have a long history in Zen, representing the path to enlightenment through the metaphor of losing, searching for, finding, riding home, and going beyond the ox. The original poems, written by the Chinese Zen master Kuo-an in the twelfth century, have inspired many paintings over the centuries, including this set in relaxed wet-brush style created for the Zen Mountain Monastery by Jikihara in 1982. He has added a short inscription that augments the original poem by Kuo-an:

> Following the winding road, you ride the ox home,
> The sound of your rustic flute pervades the evening haze.
> Each note, each song: feeling unbounded,
> Beyond lips and mouth.

Zen Commentary

In this stage of the spiritual journey, we begin to be able to navigate the complexities of life with ease and equanimity. There is a sense of unity with the myriad phenomena that we encounter. This is a stage in which there is really no turning back, although this no turning back is not dependent upon commitment or determination but rather grows out of the ease with which we are able to function. There is a sense of trust in ourselves, our life, and the natural order of things.

Ink on paper, 45 x 37.7 cm., Zen Mountain Monastery

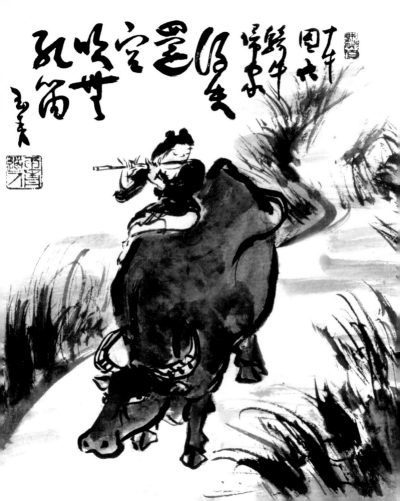

Kojima Kendō (1898–1995)
Mu Ensō (at age 97)

Art Comment

As one of the leading Sōtō Zen female monastics of the twentieth century, Kendō led a full life that combined personal practice, teaching, temple administration, social service, and work toward equalizing the opportunities for monks and nuns. In her final decade she often brushed calligraphy, usually in square *shikishi* (poem-card) formats such as this example made near the very end of her life. Here she combines two of the most familiar and potent Zen symbols, the universal *ensō* (circle) and the fundamental koan *mu*. She gives her personal stamp to both forms; the *ensō* is brushed with lively energy to become an oval, not quite ending where it started, while the regular-script *mu* is nestled within it, slightly to the left to leave some empty space for our contemplation and imagination.

Zen Commentary

The character *mu* is from the koan "Mu," found in several koan collections. It is Case 1 in the *Book of Equanimity,* Case 114 in the *True Dharma Eye,* and Case 1—in an abbreviated version—in *The Gateless Gate.* In the Rinzai school of Zen, this koan is one of several first koans that practitioners work with.

> A monk once asked master Zhaozhou, "Has a dog the Buddha nature or not?"
> Zhaozhou said, "*mu.*"

The student is asked to concentrate with the whole body and mind on this *mu* making it one great inquiry. Dualistic or nihilistic rationalizations are not acceptable. The only way to see *mu* is to be *mu* with the whole body and mind, and the only way to be *mu,* is to cast away all discriminating knowledge and consciousness. Kojima Kendō Roshi has combined *mu* with a universal symbol—the circle—that expresses the totality of our being. The *ensō* points to the most vital aspect of our existence, its ultimate wholeness. In a sense, these two vital symbols are pointing to a single reality. However, the question remains, what is that single reality? Don't tell me, show me.

Ink on paper, 26.8 x 24 cm., Hōsei-an Collection

無

賢道九十七

Fukushima Keidō (b. 1933)
Mu (1999)

Art Comment

In standard script, the character for *mu* requires twelve strokes of the brush, but here Fukushima has rendered it in a single gesture in cursive script, his own unique version of the word. In the process he has not only brushed a black form on white paper, but has also created four different and lively floating white spaces within the black shape. While the character was written with the brush moving from side to side and downward, the form itself seems to rise up with great energy from the signature written in smaller size below it. Fukushima asks us here: What is this *mu*?

Zen Commentary

> A monk once asked Master Zhaozhou, "Has a dog the Buddha nature or not?"
> Zhaozhou said, *"Mu!"*

What is this *mu*? *Mu* is the first barrier for many koan students in some Zen lineages. The heart of the question lies in the fact that the teachings say that all beings sentient and insentient alike have the buddha nature. Why would Zhaozhou say *mu* (no)?

> At another time a monk asked, "Does a dog have buddha nature?"
> Zhaozhou said, "Yes."

The only way to see into this *mu* is to let go of all discriminating thinking, take the backward step, forget the self, and be *mu* with the whole body and mind. Only then will the wisdom that has no teacher reveal itself.

Ink on paper, 124.4 x 34.9 cm., Chikusei Collection

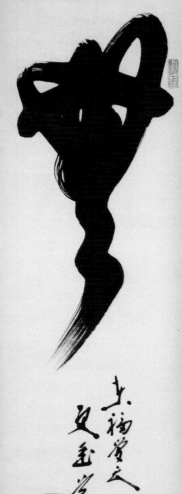

Fukushima Keidō (b. 1933)
OAK TREE IN THE FRONT GARDEN (1999)

Art Comment

This single-column calligraphy (*ichigyō*) by the current chief abbot and Zen master of Tōfuku-ji Monastery in Kyoto, Fukushima Keidō, emphasizes "flying white" in its bold cursive lines. This effect occurs when the brush is either running dry of ink or is moved very quickly, or both. Here, flying white is primarily the result of rapid brush movement, since at the end of some strokes one may see richer ink tones. The effect, also known as "dry brush," conveys a strong sense of energy which, along with the differing forms of movement in the characters, gives this famous koan a renewed vitality.

Zen Commentary

A monastic asked Zhaozhou, "What is the meaning of the ancestor's coming from the West?"

Zhaozhou answered, "Oak tree in the front garden."

Essentially, the question here is, what is the truth of Zen? Or, what is the truth of Buddhism? It goes beyond the First Ancestor, Bodhidharma, who brought Buddhism from India, right to the heart of Zen. Masters historically have answered this inquiry in very different and creative ways, and yet their answers have always pointed to the same truth. In this case, master Zhaozhou answered, "Oak tree in the front garden." What is his point? With this simple and direct answer Zhaozhou cuts away all kinds of intellectual and dualistic possibilities in answering the question "What is the truth of Zen?" If you think there is a meaning to "Oak tree in the front garden," you've missed it. If you think there is no meaning, you are a thousand miles from realizing Zhaozhou's compassionate teaching. What do you say?

Ink on paper, 131.5 x 34.2 cm., Chikusei Collection